BRIGHTNESS

Poems and Drawings

Joy Ann J. Cabanos

authorHOUSE®

AuthorHouse™
1663 Liberty Drive
Bloomington, IN 47403
www.authorhouse.com
Phone: 1-800-839-8640

First published by AuthorHouse 4/30/2010

ISBN: 978-1-4389-4404-3 (sc)
Some of these poems have appeared in SubtleTea.com,
The Baker's Dozen Vol. III and Exit 13 Magazine.
First line from David Whyte's "Self Portrait" is used with author's permission.

Library of Congress Control Number: 2009910005

Printed in the United States of America
Bloomington, Indiana

This book is printed on acid-free paper.

For the Cabanos family: my parents Eduardo and Fulceda,
brothers JJ & Jan, grandparents Juan and Venancia, Auntie Loring
& Uncle Oscar, grand-aunts Lo-Kay & Lola Ced Guerrero

And for Ed, Jaime and Javier

Contents

Invocation

Storm gathers.

May that I,
like the tidepool,
catch and cast
what light, what brightness
still escapes the clouds.

Anthem

I am tired
of dreams remaining dreams.
Today I wake,
begin the work;
believing in Gift,
in the will of Spirit,
believing that dreams become Truth
and believing, with all my soul,
that this world grows all the better for it.

Brightness

Light
is a miracle
we have learned to take for granted.

We thank Thee for light
in all its incarnations:
 sunrise, moonglow,
 candle, window,
 childsmile sparkle,
 hearthfire, heartflame.

Oh, that we may learn
in our lifetime
to grow, to glow
into the light;
into Light.

What Do You Want To Be
(Now That You're All Grown Up?)

I want to be
like the tree, in winter;
 unadorned
 unafraid
 survivor of snows
 believer in Spring
claiming my place in the cycle of seasons
 steadfast
 rooted
 ever-reaching
 ever-reaching.

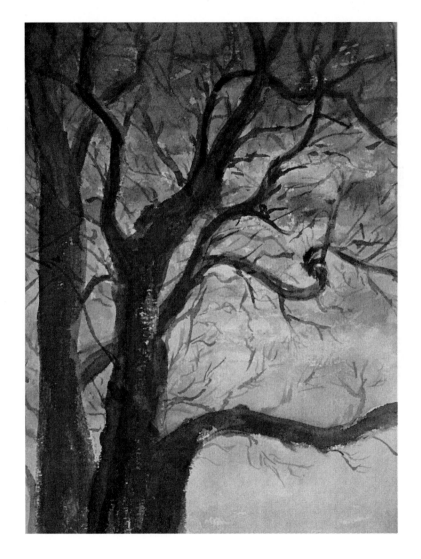

Guardian Tree GU254TB *watercolor, 2006*

A Piece of Sky

This is the bit of sky I see
same sky that floats above you and me
same sun, same light
same breezes give this mem'ry flight.
I see the sky, I think of you
oceans away,
still beneath this same blue,
my heart heaves a little sigh –
we cannot touch, you and I,
but we can embrace
in this gentle, blue,
I'm-here-with-you-I'll-always-be
same sky that floats
above you and me.

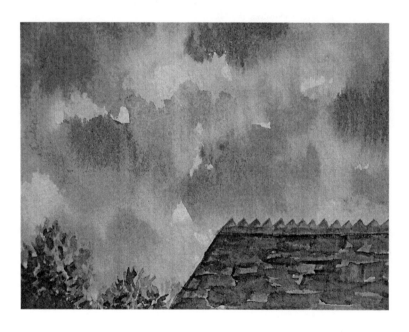

Skyscape, Virginia Water *watercolor, 2006*

Ode to Wildflowers

I admire the wildflower
because it spends itself
in unabashed bloom,
undeterred
and faithful in its worth
even though
it is a mere pinprick of color
in nettle-choked corners where nobody goes,
even though
it is unwelcome
in the well-tended beds of blossoms
deemed worthier of our gaze.

Stream, Bright Morning

This is not a looking glass,
this is a seeing glass.

It gives no room for admiring
the mask you don for your day.

Look deep—
find bright pools of stillness
now surfaced, now swallowed
by rapids roiling strong.

Catch
quick flashes of your true beauty
as it dazzles fleetingly
in the torrent of all that is alive and wondrous.

Rondo Alla Turca

for Juan Cabanos

My warmed-up fingers dance the keys,
reliving youth decades gone.

Years melt,
and there he is – Juan –
shrivelled into the muttyellow couch to my left.

His gaptoothed grin fills the room,
gnarled hands applaud
granddaughter in concert.

Lolo gloried in my gifts.
Why the hell did it take me forever
to do likewise?

"Lolo" means "Grandfather" in Tagalog.

Nilaga

for Venancia Cabanos

Soup
simmers memory.

Sustenance
ladled by Lola
to warm and calm
on wet thunderous nights
long, long,
too long ago.

Now served of me,
heady with flavor and remembrance
to warm and calm
on blustery frozen nights.

Filling, soul-bracing proof
that love spans generations—
 clear,
 nourishing,
 undiminished.

"Lola" means "Grandmother" in Tagalog.

Study for a Mother-Daughter Portrait
for *Fulceda Cabanos*

I draw
with tenderness,
lines defining this visage
which in time
becomes mine.

Mothers and daughters
are parted
by distance, by silence,
by hemlines, boyfriends, career choice
and other such seeds of disagreement,
but still can choose reunion
because in the beginning,
there was an embrace
time cannot erase.

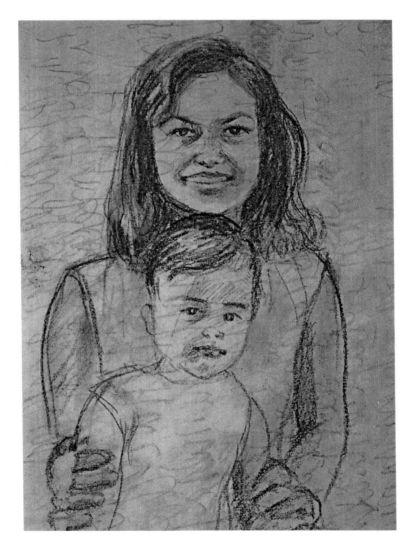

Study, Mom and Me *charcoal, 2007*

Favorite Photograph
for Eduardo Cabanos

Snapshot of a random moment
spent in timeless togetherness.

His smile
carries over mountains and ocean swell,
through years and yearnings.
It finds me here,
bereft though I be
I am grateful for the blessing of remembrance.

His laughter echoes, reassures
that a father's love goes on unhindered.

His smile, his laughter—
my beacon,
anchor and pennant,
my true north.

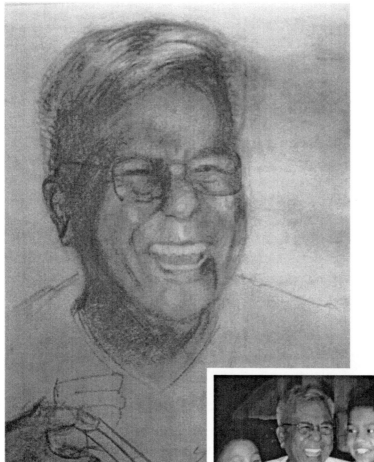

Study for Dad's Portrait
charcoal, 2009

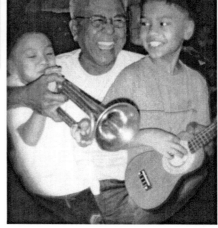

Smiles & Music

Childspeak: Daughter Writes Two Love Poems

Written when I graduated high school. These poems are unedited.

Poem for Mom

"Mommy dearest, mommy sweet
mommy good and mild…"
these were words I wrote of you
when I was but a child.

But time has changed me; change has made
a diff'rent melody
have I sung it to you, Mom?
for I sometimes sing off-key

but still the words ring in my soul
the feelings swell and grow
and they are what I can't hold back
I just want you to know

that now you're more than dearest Mom
more than my friend and guide
you've grown to be a part of me
a living voice inside

I'd like to let you know dear Mom
for it's rarely that I do,
I appreciate all you've done for me
and Ma, I do love you!

A love like mine for you is strong
because it stems from yours
thank you Mom, this love you've grown
is magic we'll call ours

for like you say, time is too short
and every moment counts
now I leave behind the past
my childhood sights and sounds

but you will always be with me
throughout life's changing weather
Come what may, I will remain
to you – your loving daughter.

Poem for Dad

To the greatest Dad a girl could have
the best I'd ever wish for,
to my ever faithful, ever caring,
watchful lord protector

to my fav'rite clown who always
cheers me up with laughter,
my savior who won't fail me when
my troubles runneth over,

to dearest Daddy, how could I
be here and now without you?
and yet the times come rare and few
when I say "Thanks, I love you!"

and so here is the chance for me
to say what fills my heart
Thank you Dad, for everything
I've loved you from the start

I love you here, I love you now
tomorrow you will see
how all your love and sacrifice
has made a better me!

Someday you will be proud to show
the world your "little" daughter
and I in turn will not forget
the debt I owe my Father

for time flies fast, and you will change
and I will grow old too
the only thing that will remain is
what love like yours can do.

Again, Dad, thanks and as I leave
this small world for another,
I'm not afraid, I'll make it thru
for you, for us, forever.

Soldier's Wife

Phone Call from Mindanao

Static spits and crackles
churns the line
like storms on the ocean
between home
and where you are.

She grips the handset
white knuckled
and shouts to speak,
to drown the distance, the danger
that keeps you from where you ought to be,
here with us; your wife and children.

You are far away
at war
and she knows too well
how easily the line could be cut,
leaving her truly alone.

Only now I know
how brave
my mother was.

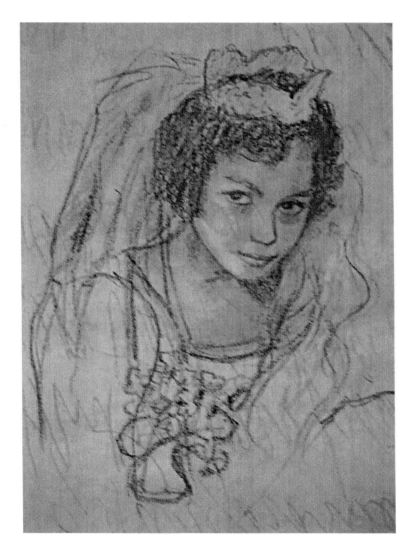

Portrait study: Bride, 1964 *charcoal, 2008*

Anniversary

for my parents, in celebration of their
30th wedding anniversary, May 1994

How fast time flies! We often say
as Now fades into Yesterday.
Our cherished moments come and go,
the New Years pass, the children grow.
Some dreams come true, some dreams just die
good fortune can touch us or pass us by
but always our sun will rise, set, rise;
each morning finds us one day more wise
and one day more blest, for this love we hold
with memories shared grows strong, grows bold.
So even if for us Time will not stand still,
Tomorrow will beckon, and seek it we will,
always with Yesterday dear in our hearts
and Now lived in fullness, in joyous part;
Each other we cradle in true love and care,
With hope and deep faith in this Journey we share.

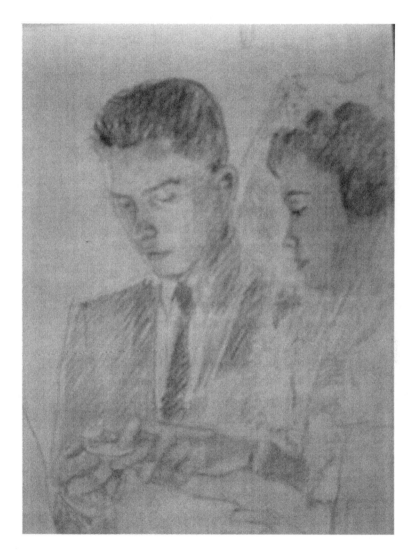

Study: Wedding Ring Moment *pastel and conté, 2009*

Learning to Walk
for JJ & Jan

Come little brother,
I'm learning to walk
and how to rise when I stumble.

Here's a handhold
across this vast ocean divide,
I am here, I must walk this road
You are there, you must walk yours

Please take my hand and hold it;
step one-foot-in-front-of-the-other along with me
onto each our own separate journeys.

 Hold on, yet feel the earth solid beneath you.
 Hold on, yet feel your strength gather.
 Hold on, yet feel your horizon pull.

Know we are stepping into surefootedness,
finding strength even if sometimes afraid.
We all fear passing shadows
or stones that might trip us.

Come then, brother, take my hand.
We can grow steady together
and when we let go
I will pause,
watching you with love and pride
as you walk, run, fly into the promise of your dawn.
I will smile, hit my stride and blaze into mine.

Sibling Smiles *pastel, pen 2008*

Lasagna a la Lola Auntch

for Loreto Cabanos and Javier

She cannot be with us today, Javier,
but here it is, her love—
oven-fresh and steaming
layer upon layer of al dente comfort:
marinara, béchamel,
tender meat and spices,
melt-in-your-mouth cheese;
self-sacrifice and strength,
gentle smiles,
caresses and care
all baked into this fragrant feast.
Here it is, her presence—
partake
and fill with the flavor
of her constant love
as it journeys over a separating sea
to assuage our hungers.
Here it is, lasagna a la Lola Auntch—
her blessing on our table
wherever, whenever we may roam.

Lola Auntch is a nickname for my Aunt, meaning "grandma-aunt" in Tagalog

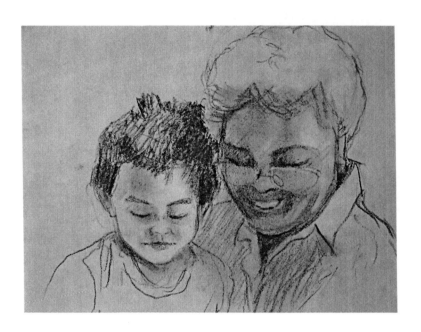

Portrait study: Javier and Lola Auntch *charcoal, 2007*
plant a windowbox garden

Requiem

for Oscar Bonifacio Cabanos, 1930 - 2007

The cherry blossoms were in flower
when you left us.
I was not by your side,
but I can picture
how labored breath and ebbing will
found release
from the measured drip of medicines
and tearful prayer.

I'd like to think
you gained the freedom
of a burgeoning springtime
on this far side of the world.

Was it pink, Uncle?

Through pain,
and fear of the unwanted parting
was it lush and many-petalled,
blue-skied and green-budded,
this new,
this everlasting life
that has reclaimed you?

Being There

for Francisca and Mercedes Guerrero

For you who lived
in the periphery of my strong-striding youth,
who were always ready with caring gestures
or any small comfort
from clouded eyes and withered hands;
for you whose fading bodies
I was always too young for,
from whom I strained away even as you hoped to keep me close
so you could whisper what wisdoms you knew of home and of love;

These words,
these belated embraces
are for you.

Invoking your memory.

Treasuring now
the priceless gift
of your being there,
your unsung presence enriching my life
well beyond the reach of yours.

Accendó

I dance
because I burn.

Should I not dance
this fire turned inward
devours
what light I might let glow.

Why bring such destruction
on a world already too full of it?

*Accendó: in Latin, "I kindle"
or "I inflame"*

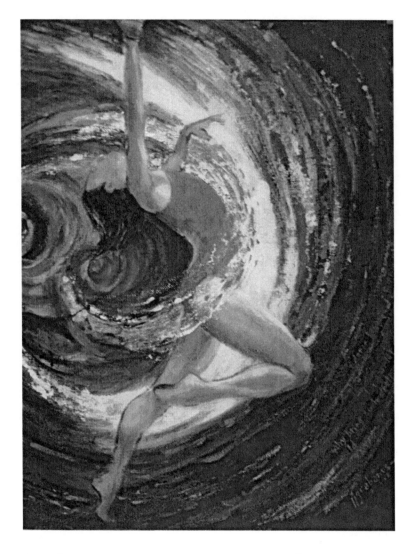

Accendó *acrylic on canvas, 2008*

The Feel of Arabesque

craving endlessness:
reaching forward
stretching back
daring to pull
past and future
into balance
even if only
for one vital moment
that hints of forever.

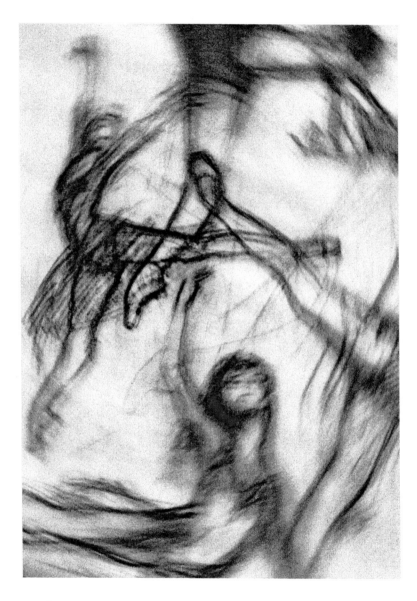

Arabesque Con Brio *charcoal, 2009*

Flight

I wish
I could dance like this—
exploding boundaries as she does.

But then, I am an earthbound creature
meant, I still believe

to soar

in ways other than grand jeté.

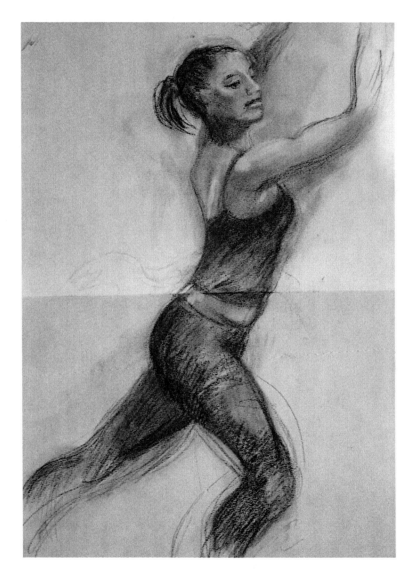

Preparation *charcoal and pastel, 2007*

Adagio

Leaning into the curved legato
she flows ethereal,
surreal.
A moment of untruth, this,
the ransom paid is steep—
pain blood tears the least of it.
Such obsession
with perfection
demands no less than
youth handed over.
Applause will end;
she might be left an empty shell
if she's not careful.

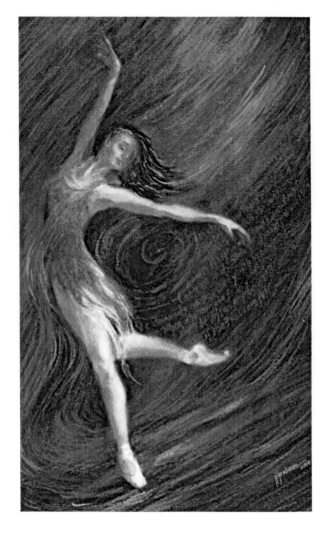

Flow pastel, 2007

Not Dancing

You may think me a sylph
or some raptor unfettered by gravity,
but I am human too.
I bleed.
I cry.
I know how it is to reach for a dream
and see it, maddeningly,
still beyond grasp.

Not Dancing *charcoal, pastel 2007*

Babaylan

storm sky, wild sea
cold black sand,
intonation, incantation,
gnarled, steeled hand
takes me, breaks me
am flung into the waves;
once, shatter
twice, sputter
thrice I become brave.
I hold my breath
I hold my own
I struggle from the drowning.
Returned, three summers,
childhood's gift—
babaylan,
brinefroth crowning.

"Babaylan" is a priestess, seer and healer in Philippine tribal culture.

Formidable

She owns
her serenity, grace
her sureness of soul
and faith in a future shaped with hopeful hands.

She hears
the names they call her:
ungrateful, joyless,
but she's chosen whom to believe.

She knows
beyond all handholds,
each one is required
to answer
alone.

She cries
hot tears to thaw
worlds frozen within.

She's learned
that Sleep is a lover,
and Death, the angel who blesses
her cup of days and nights.

She will drink of it
deep,
lustily.

Self Portrait

Roll my eyes
at coos and sighs
that glorify perfect nailpolish.
I crave the beauty
of the workstrained hand
that molds the shape of courage
in daily thankless tasks.
Not needing decoration
not seeking admiration,
but wanting
and claiming
each chance at creation.

lefthandspeak *pastel, 2008*

Self Portrait
(after David Whyte)

It does not interest me if
I fail,
or if I fail.
What I want to know is
when it happens
can I cry,
then sigh,
then brave a smile
and know
that tomorrow is another day?

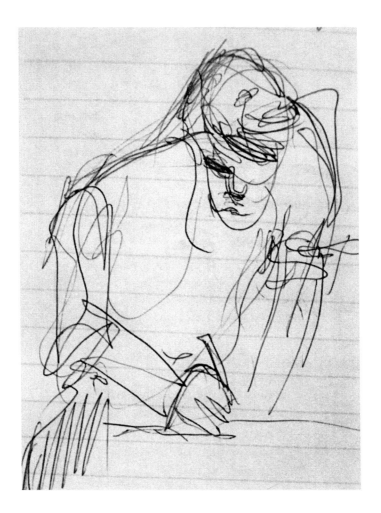

The Poet, Mid-poem *ink on notebook paper, 2006*

*"Self-Portrait (after David Whyte)" and "The Poet, Mid-Poem"
came into being at a workshop given by poet David Whyte in
2006. At one point he read and discussed "Self Portrait" from
his book "Fire In The Earth". He then invited us to likewise
write our own self portraits, offering his poem's first line "It does
not interest me if..." as takeoff point. I finished before most, and
looked up to see that David had joined us in the experience and
was writing as well. It was the perfect moment for a sketch: the
poet mid-poem, a study in stance, intent and intensity.*

Marionette Dyptich

18

Across the stage the puppet danced
almost gracefully;
her mystic smile, yes, for a while
had seemed so real to me.

The show then ended, backstage I saw
the puppet hung on hooks.
Such a pity, her dazzling beauty
vanished when I looked.

No life behind the painted smile
no heart, no will, no soul.
She was a thing of wood and string
without one who controlled.

And so I ask these questions now,
am I my person yet?
Am I a toy, an empty joy,
just like that marionette?

36

The strings are gone, this marionette
now dances on a diff'rent stage.
Her eyes can see, her heart can feel
such gladness, sorrow, need, such rage.
Hands and feet move at the call
of that which is her own now;
mind and heart and soul and self
from wood and string have grown now
into warm flesh and pulsing blood
and quiet, strengthened will;
A faith is found!
A life is learned!
Once puppet,
she is real.

Sunrise

I tried to paint your sunrise, but
somehow the colors failed
to catch the dawn, which when compared
to you, has somewhat paled.

I tried to draw the way you clear
my clouds when I'm in doubt,
to mirror all those golden thoughts
your eyes tell me about,

all that you are to me, I've tried
to form into the sun's first rays
but somehow, it just cannot be,
no sun can ever take your place

no sky grown pink in flames can make me
feel the warmth you bring with you
no morning songbird's symphony
can, like your laughter, ring into

the depths of one such soul as I
who seeks the evening's end;
my East may not be sun-kissed yet
but the promise holds…
for I've found you, my friend.

Ode to the Redhead
for E.M. Castonguay

She knows the birthing sun is red
She knows the dying day is red
She knows bloodrivers run deep red
'neath myriad shades of vesselskin:
 ebony or alabaster,
 copper, ocher,
 or every hue of honey.

Neimov

Sydney Olympics, 2000

This is the high bar of Alexsei.

He knows that falls,
failed attempts,
heartbreaks
too many to remember
are unavoidable
and necessary
in his quest
for the sublime.

There is,
my friend,
a high bar out there
 with
 your
 name
 on
 it.

Dawnsong

darkness shines deep blue
deep hued deep dreams
fill my eye fill my sky
then disappear when dawn breaks
help me help me not forget
truths revealed but unowned yet
help me help me hold onto
this deep blue deep hue
that disappears when dawn breaks

Daemon at Dawn

Soft cerulean bluegray
calms the hard stance of my guardian trees
as morning tiptoes into view,
its cold pale cloak
pulsing translucent blush, fluorescent rouge.
Gossamer clouds flit before
the sleepy sun's ascent.
Daemon,
long awake,
who has pushed me out of slumber
even as I clung stubborn,
flirts and whispers:

 watchthecolorsseethecolorsyou'vebeenblindedbylooking
 intoyoutoomuchofcourseit'sdarkinthereyou'veshut
 soulwindowslonglonglongagosowatchthelight,catch
 thelightthatchangestooquickly!itisthere,intransforming
 hueandtintandshadeandshadowyouwillfindthegift,
 thegiftsfreelysentbutyoumustwake,musttake,must
 shapetheseasheartandhandsknowhow.Thengiveback
 intoceruleangrownolder,grownbolderinitsneedofyou.
 Giveback,andyes—youwouldhaveearnedredemption.

Sun Salute

Dark trees filigree into
a slatesheen predawn sky.

Where are you, sun?

You should be here by now.

Treetops scurry
and worry
but the heart of the forest is still.

It knows
morning will splash
dappled kisses
in time, in time.

Shadows whisper:

 wait.

 breathe.

 wait.

Three from 9/11

Praying in the Garden
9/12/2001

Flowers are prayers
and prayers start healing;
We trust to our Lord
this grief we are feeling

our helplessness, anger,
vengeance and fear,
despair and the questioning:
where is God here?

Let flowers remind us
Yes, hope stays in reach
in simple, in small things;
in the kindness we teach

by our good examples
and prayers we pray,
by actions of loving
to all, everyday.

So though we can't be there
to battle the fires,
to save shattered lives
as we surely desire,

our challenge is Here,
our call is to show
that Good springs eternal
just as flowers grow

So look to the flowers
let them help us pray.

May our prayers for Peace
come alive in all we think, say and do
today,
everyday.

In memory of all who died in yesterday's attacks, and of all victims of terrorism around the world specially those who have gone unheard of and unmourned.

In companionship and sympathy to all whose lives are shattered by violence in any shape, form and scale.

In gratitude to the courageous people involved in all aspects of rescue, investigation and rebuiliding efforts in this tragedy, and all like it the world over.

Blessings, encouragement and hope to all of us who carry on, in ways big and small. May we learn to keep Faith strong, may we seek Peace bravely in each our own way.

Broken Crayons
9/15/2001

We are all broken crayons
but we can still paint a picture of peace.
Though shattered,
though crushed,
WE ARE
STILL
 the purity
 the vibrance
 the life-force
of colors
that can hold the vision of a world
beautiful and peaceful
as it was meant to be.

This poem came about when I volunteered to organize the children's craft activity for a community peace gathering held in response to 9/11. To avoid spending on supplies, I asked friends to donate used crayons their kids no longer wanted. It seemed prudent at the time, but as the event neared I wondered if the ragged assortment of crayons I had collected would entice anyone to join in the craft.

A thought then hit me -- these castoff crayons, when put to paper, continue to color as pure and true as when new. They became a metaphor for the human condition: our failings, our possibilities, and our beauty when we are true to our creative nature.

I began writing the poem the day before the gathering, and finished it in time to read it then. It comforted many broken hearts, including mine.

Jaime & Javi start the "Broken Crayons" collage *Sept. 2001*

Soon after it was written, "Broken Crayons" evolved into a mirror-collage made of the crayons which inspired the poem, and various small bits of paper on which friends and neighbors had drawn their interpretations of "a picture of peace".

Today

A poem for those mornings when I'm at war with the world

...and so, today
do I add? take away?
destroy? create?
spread love? spread hate?
build up this smoldering pile of injustice?
or buttress the pillars of small, honest joys?
 I have mind
 I have heart
 I have will
 I have freedom
 It is,
 it is
 a choice
 —my choice.

Airborne Over Manila, 2002

carry-on package of light
granted me
as I wing away
from home that cradled and taught love

oval windowful of sunsplattered hues,
palette swirled with yellows, golds, green-tinged ochres,
neon pinks, apricot and crimson tints,

all mine
to take
and paint into
my wintered destination.

Colors from A Past Life

Bohol, Philippines

They blaze at me,
furious:
azure waves and blinding sands
bright bougainvillea's livid blush

"You have forgotten,
YOU HAVE FORGOTTEN!
And now your world is puttypale;
you've chosen lies, not life force—
that pixel sun,
that jpeg sea,
those plasma blooms
which will neither kiss nor bless you."

Waiting

This is the thought
that keeps me alive through winter:
 tiny seeds patient in the darkness
 preparing to blaze forth in their time.
And their time always comes
in the ceaseless round of seasons.

In the Louvre Without a Camera

One day, I was
in the Louvre without a camera,
the biggest mistake a tourist could make.

But then Spirit did not intend
that I walk those halls a spectator
snapping *I-was-there* souvenirs.

That day I was swept up
by ghosts of artists past.
Spoken to, shaken and screamed at
by brethren who have trodden a road
I dare dream of taking
yet fear taking.

Fateful day! I am
dizzied, engulfed
in the almost physical embrace of
those who came before me.

"Come drink, come be,
WHY DO YOU NOT?"

And my naysayer falls in a crumpled heap
turned to dust that scatters in the footsteps of crowds.

New day, I was
reborn
in the Louvre without a camera.

North Light at Denmark House

Windsor Street, Chertsey, UK

pale wash of sun
from two northfacing windows
graces the muse in her sculptured pose.

And we, the privileged few
who have apprenticed ourselves
to line and form, to color and shadow,
to exquisiteness and expression;
we marshal our senses in vibrant expectation
 and feast
 on
 light —
let it course from eye to brain
to heart to vein to hand
till it finds life
on the waiting paper.

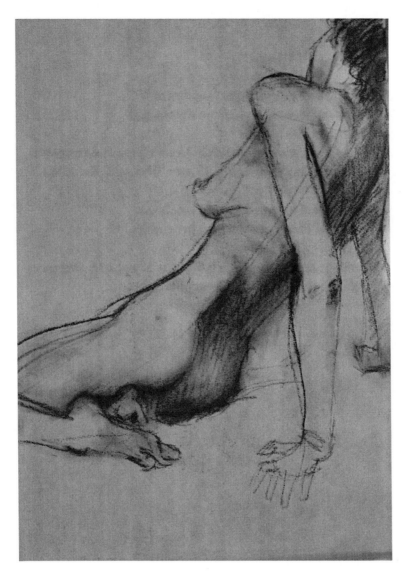

Languid *pastel, 2006*

Twins, Firenze

I returned to my room past sundown;
the heat of Florentine dusk on my cheeks.
I am weary, but filled.
Names gush with my breath in rivers of awe and reverence:
Michelagnolo, Brunelleschi, Giotto, Botticelli, Rafaello...

She returned to her room past sundown;
the heat of Florentine dusk on her cheeks.
She is weary, but laden.
Names gush with her breath in rivers of awe and reverence:
Fendi, Armani, Versace, Coveri, Ferragamo...

Ancient Place

Tintagel, Cornwall, UK

I hurtle out of
windsculpted grass trenches
into the silvergrayblue of seasky, skysea.
Cornwall breaks,
wavelike over this traveler's torpor
and I am bewitched.
Blown to rainpelted cliffedges.
Drawn by incessant chanting surf.
Seeking,
as pilgrims ever have,
a magic thought long dead.
Is it here?
In this ancient place?
Perhaps. Sometimes
in the sheen of wet caves
resurrected at each long ebb of tide,
in ghosts, flitting ruin to ruin among the bones
of a cragtop fortress.
in bright bells pealing high noon from the Arcangel's abbey.
Perhaps. Sometimes
even in muffled, disquiet remembrances
astir in my own dark heart.
And I, bespelled,
must dare
to call such magic forth.

Out of Richmond Mornings

above the Slug and Lettuce on Water Lane,
Richmond, UK

Birdcall above water.
I sit among winged creatures,
they wheel and weave.
This balcony makes me neighbor
to nesting egrets atop willows.
I listen,
watch,
tensed for first true flight perhaps
seeking avian instruction

> "This is how we spread our wings,
> how we embrace solid air
> and then splash in it.
> This is how we release ground and river
> then return at will.
> This, how we claim the abundantly given:
> wind, water, sheltering trees,
> sustenance from nature
> and from little hands offering bread."

Birdcall above water.
I sit over a city awake,
it wheels and weaves.
This balcony makes me witness
to bus, train, rushing footfalls 'neath.
I listen,
watch,
tensed for first true flight perhaps
seeking avian instruction

—there it is! Cacophonous in rush-hour wingbeats;
chirped, cooed, cawed, trilled
honked, trumpeted, squawked–

> "Come!
> Live truthful and exultant!
> It!
> Can!
> Be!
> Done!"

Incident in Norfolk

around Norwich, Norfolk, UK

Sky claims horizon.
Low-slung clouds drip gray tendrils
into distance-faded fens
yet color screams into this windsilvered morning;
greens rant and roll into each other,
all manner of reds and rusts and earthen hues
stand their ground
in the onslaught of sudden rain.
And the rapeseed,
brazen lemon yellow,
collars me, exclaims:
"You cannot pass through here
and NOT live!"

Marching Orders

do not stay in
the pretty house
with its vampire energies.

don't buy
the lie
that sky's contained
in windowpanes.

claim the kiss of autumn sky,
seek baretreescapes
burnished warm with summer's slow leave-taking.

do not stay in
for house is not home yet.

but you know
that sky
that trees
have always been.

Sounion Song

Cape Sounion, Attica, Greece

could I
would I
should I

love you

staunch
as these columns of ancient marble
once torn from begrudging earth
and planted audaciously
atop this unforgiving crag?

they've withstood tempest and forge,
weathered eternities of rapture and despair.

should I?
would I?
could I?

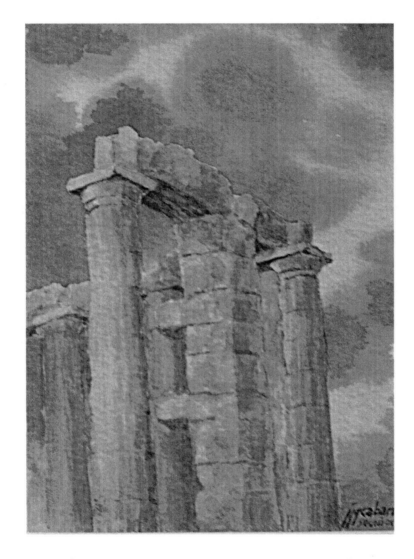

Pillars of Poseidon *watercolor, 2006*

Swift Sunrise
07090

It's gone —
where is it?

Quickbright shard of flashfire
that razed this scaffolding of branches
holding up my morning's leaden sky.

Gone

pierced right through me

exploded
into sparkled flecks of firefly glow,
settling unbidden
on lonely unlit corners
of remembrance.

Epiphany

I just realized—
I am not afraid of death.
I fear
the waste of gift,
a wasted life.

Cupful

I throw my little cupful,
no— dropful
into the flood
and Become
in the roar
> that carves out canyons
> where mountain walls were,
> that caresses stone
> into grains of yielding sand.

Cadence for the Rapids

Pagsanjan Falls, Philippines

go river, flow river
tell me what you know, river
have I stayed
or have I strayed,
drowned or died of thirst?

foam river, roam river
find me my lost home, river
will I lose
if I must choose
'tween loves; my lasts, my firsts?

brood river, flood river
christen with your blood, river
dare I learn
to take, return,
these days in joy immersed?

Labyrinth

there are days
when all I can muster
is one foot before the other,
one step before another.

way too little.
never enough.

but

could it be, could it be?
that one foot before the other,
one step and then another
is all You ask of me?

Entreating the Rooted Guardian
15 Cypress Ct.

Tree, Tree
roam with me,
shelter this frail pilgrim soul
that's blown across the sea too soon;
catch in your arms
my brother, Moon,
to light this trail I cannot see,
please journey, journey,
Tree,
with me.

Chant for Walking the Roundabout
GU25 4TB

Oh my! oh sky!
ah grey! ah blue!
come sun! come rain!
fill me, fill you.
Touch love, touch loss
this root, that bud!
Some felled, some saved
What might, what should!
Oh green, oh branch
where bird, where tree,
ah song, ah breeze,
find him, find me!
Here, vows; here, choice
Hold together, stand alone?
Fly far, stay near;
Crave home, crave home.

Credo

Forgiveness
brings wings.

I'll span breadth of ocean
to stand in pools of Chartres blue
and drink it in and drink it in,
begin again, begin again,
this time as Truth-teller.
The one who peels the rainbow off the floor
and hoists it
onto worldwearied lines of sight.

Acknowledgements

My heartfelt gratitude to Ed for his unwavering belief and support; and to Jaime and Javier for their love and patience.

And always, my love and deepest gratitude to the Cabanos family– my parents, brothers, grandparents, aunt and uncle, and grand-aunts; the family who gave me roots and wings.

Special thanks to Elizabeth Myers-Castonguay, Barbara Sher and David Herrle, my early encouragers; to David in particular for making time to comment on this manuscript.

And thank you, thank you

To Linda Nederkoorn, Deb Gale, Mary Olson, Sue Feinberg, Lisa Seabourne, Marilyn McDougall, Gigi Priebe, Corrine McCorkle and Ellie Dunham; Jan Gittus; Maura Werner— fellow writers and poets who have been listeners, cheerleaders and gentle critics as needed.

To David Whyte, whose voice and work is a constant inspiration; to Julie Quiring for her help and encouragement. To Weezie, who was instrumental in this without her knowing. To Ruth Duffield, who helped me stir the simmering pot. To Cathy Babao-Guballa, also an inspiration and soul-sister in the creative journey.

To Margaret Robinson and the artists at Denmark House; to Frank Halliday; to Aurora Spain and the Rendezvous Renoirs. To Marion Mansfield; to Inger-Kristina Wegener.

To Dr. Harris "Cole" Vernick , Yvonne Marie Crain and Maxene Alexander of the Cole Foundation; the South Mountain Poets, Tom Plante and the Carriage House Poetry Series, Leona Seufert, and again David Herrle, for opportunities to read and publish my work.

To Marybelle Nuguid-Ignacio, who in the 5th grade gave me the little Hello Kitty™ diary which became the first keeper of my poems.

To my mentors: painter Fernando B. Sena; ballet teachers Effie Nañas, Leonor Orosa-Goquinco, Rachel Braganza and Shirley Halili-Cruz; English teachers Bernadette Windsor, Miss Mallabo and Dulce Afsal.

Maraming, maraming salamat.

About the Author

Joy Ann Cabanos grew up in Manila, the Philippines; moved to various cities the US, lived in the UK for a few years, and traveled in England, France, Greece and Italy. Her poems have been published in SubtleTea.com and Exit 13 Magazine. A collection of her poetry entitled "Roots & Wings" is included in "The Baker's Dozen Vol. 3", an anthology of works by international poets published by The Cole Foundation, 2009. As a painter, she has had several shows and continues to exhibit her art locally and internationally. Her last solo exhibit, "New Eyes" (at Windsor Street Gallery, Chertsey, UK) featured her paintings and poems together with great success. "Brightness" grows out of that pairing. This book reveals the essence of Joy's artistic process, which finds her creating in the confluence of many loves: color, line, image, words, phrase, story, song, music, dance, family, nature and spirit.

Breinigsville, PA USA
04 January 2011
252608BV00002B/10/P